Carolyn Lanchner

D0197252

Paul Cézanne

The Museum of Modern Art, New York

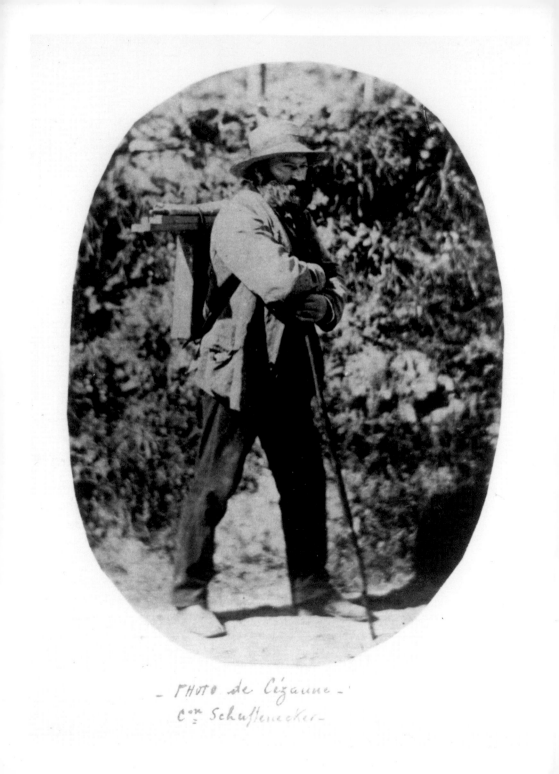

- PHOTO de Cézanne -
Coll. Schuffenecker-

This book presents ten works by Paul Cézanne from the collection of The Museum of Modern Art. Cézanne occupies a unique place in the Museum's history as one of the four artists featured in its first loan exhibition. Included in that formative 1929 show were *The Bather* (pictured here on p. 12), *Still Life with Apples* (p. 20), and *Pines and Rocks (Fontainebleau?)* (p. 27). These paintings were among the first works by Cézanne the Museum acquired, entering the collection in 1934. By 1977, when MoMA mounted *Cézanne: The Late Work*, it had acquired ten more works by the artist, including the iconic *L'Estaque* (p. 9) and *Château Noir* (p. 39). A major exhibition of Cézanne's drawings followed in 1988, and in 2005 the Museum mounted *Pioneering Modern Painting: Cézanne and Pissarro, 1865–1885*. In 1929, the year of the Museum's founding, director Alfred H. Barr, Jr., described Cézanne's importance to modern painting: "By infinitely patient trial and error," he wrote, Cézanne arrived at "conclusions which have changed the direction of the history of art." This volume is one in a series featuring artists represented in depth in the Museum's collection.

3

Paul Cézanne on the Way to Paint His Favorite Motif in the Region of Auvers 1874
Musée du Louvre, Paris

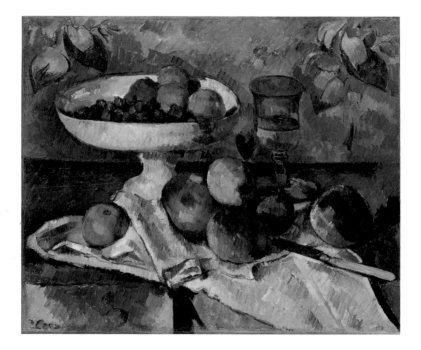

Still Life with Fruit Dish 1879–80
Oil on canvas, 18 ¹/₄ x 21 ¹/₂" (46.4 x 54.6 cm)
The Museum of Modern Art, New York.
Fractional gift of Mr. and Mrs. David Rockefeller, 1991

Still Life with Fruit Dish

(1879–80) Around 1895 Paul Cézanne let out that he wished to "astonish Paris with an apple." In a skewed pun on Greek legend, the artist's logic went something like this: if an apple had won the beautiful Helen for the Trojan prince Paris, then one of the many he had painted ought to win him uncontested recognition in the Paris art world. Like many jokes, Cézanne's had a bitter edge. By the time of its formulation, his art had done its part to startle Parisian arbiters of aesthetic good manners—who had been provoked first by Impressionism in the 1870s and thereafter by Post-Impressionism. Although associated with both groups, Cézanne's art refused group definitions and was subject to particularly dismissive or vituperative notice. An unusually enlightened critic wrote that Cézanne had "his own legend." Further, he evidently saw the artist's rejection by the jury of the Salon of 1874—before whom Cézanne had appeared "carrying his canvases on his back like Jesus Christ his cross"—as a martyrdom imposed by a blinkered officialdom.

If Cézanne occasionally found defenders in the press, he had deeply respectful, even ardent admirers among his Impressionist and Post-Impressionist peers. His staunchest supporter was Camille Pissarro, who called a critic to account for not mentioning the painter "whom not one among us would fail to acknowledge." Most uncritical was Paul Gauguin, who owned at least three Cézanne paintings. *Still Life with Fruit Dish* was, however, closest to his heart, and in the midst of severe financial difficulties he refused to sell it: "It's the apple of my eye and unless there's an absolute necessity I would part with it only after my last shirt." Years later, virtually penniless and in need of an operation, Gauguin finally allowed its sale. In a manuscript written shortly before his death in 1903, he described his lost painting: "Ripe grapes overflow the edge of a fruit bowl: on the linen the apple-green apples and the plum-red ones are linked to each other. —the whites are blue and the blues are white. —A holy painter is this Cézane [*sic*]."

Brief as they are, Gauguin's words reveal his grasp of just how exceptional his picture was. His reference to the linking of apples comprehends the totality of the composition, how its seemingly casual arrangement results from a carefully designed system of linkages established less by contiguity than by visual alliteration. The not-quite-round apples in the lower stack—symmetrically flanked by two more, one "apple-green," one "plum-red"—are rhymed in the smaller stack within the fruit dish. The ellipse of the dish is repeated three times in the nearby water glass—in the rim, the liquid's surface, and the base. The floral pattern of the blue wallpaper echoes the general interplay of

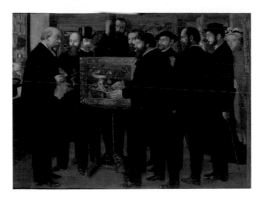

oval forms, even as its rectilinear expanse complements and reinforces the sense of spatial flatness imposed by the brown stripe of the tabletop. Its edge canceled by the blue/white cloth, the table's surface makes no claims to depth, yet the objects on it do not lack stability. On the contrary, modeled by color alone in the organized, parallel brushstrokes that structure the picture throughout, each luminous fruit achieves a material density of immense pictorial force. Indeed, this painting is one of eleven still lifes probably painted between 1879 and 1880 that are now recognized as important in locating Cézanne's transition from his personal variation on Impressionism into his own mature style—in effect, one of the first realizations of his wish "to make of Impressionism something solid and lasting like the art of the museums." A generation on, Pablo Picasso analyzed the solidity of Cézanne's apples: "He hasn't actually painted apples as such. What he has done is to paint the weight of space on those round shapes. . . . It's the weight of space [that] counts."

Cézanne's desire to "astonish Paris with an apple" was symbolically gratified in 1900 when Maurice Denis turned the attention of the city on him with his *Homage to Cézanne* (fig. 1). The painting shows an easel bearing *Still Life with Fruit Dish*

7

1 Maurice Denis (French, 1870–1943)
Homage to Cézanne 1900
Oil on canvas, 70 $^7/_8$" x 7' 10 $^1/_2$"
(180 x 240 cm)
Musée d'Orsay, Paris

surrounded by an admiring group of famous artists and other celebrities, among them Denis himself, Odilon Redon, Édouard Vuillard, Pierre Bonnard, and the dealer Ambroise Vollard. By then a recluse in his native Aix, his life devoted to painting, the aging Cézanne wrote to Denis expressing his intense gratitude. Replying, Denis spoke of how happy he was that "in the depths of your solitude, you are aware of the commotion that's been made over *Homage to Cézanne*. Perhaps you will now have some idea of the place you occupy in the painting of our time."

L'Estaque (1879–83) By his own account, Cézanne lived in the perpetual attempt "to realize my sensa-

tions." Achieved, his goal would unite perception and apperception, would capture in material form the ever-shifting moment when the act of seeing fuses optical and mental events. This double-sided experience was what Cézanne called his *motif*. As such, L'Estaque, a fishing village near Marseille, particularly attracted him, and he painted it many times during the late 1870s and early 1880s. Not only did the town provide splendid views over the Mediterranean, but it was also rich in memories of his youthful wanderings in the Provençal countryside with his close friend Émile Zola. Vacationing in L'Estaque in 1877, Zola wrote of being "raised on these rocks and on these bare moors. . . . I'm moved to tears when I see them again. The pine scent alone brings back my youth." The artist's attachment to the place was no less intense than the writer's.

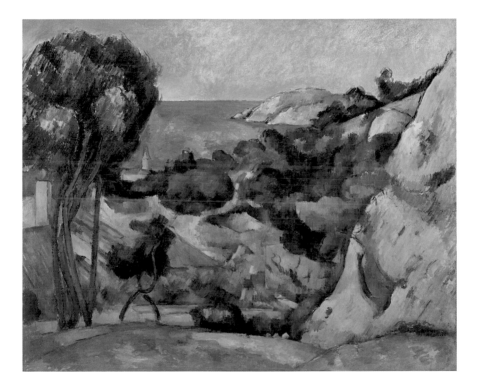

L'Estaque 1879–83
Oil on canvas, 31 $^1/_2$ x 39" (80.3 x 99.4 cm)
The Museum of Modern Art, New York.
The William S. Paley Collection, 1959

In May 1883 Cézanne wrote to Zola, "I have rented a little house and garden at L'Estaque . . . where behind me rise the rocks and the pines. . . . I have some beautiful viewpoints here." In this picture the large pine to the left and the cliffs to the right suggest that Cézanne may have set up his easel just above the house described to Zola. Allied with the slanting red roofs just below it, the pine establishes a diagonal thrust countered by the facing mass of plunging cliffs. Between them they create a V-shape that flouts the rules of traditional perspective, in which diagonals recede to a vanishing point deep in pictorial space. Thus inverted, the triangle the Old Masters used to illusion depth leaves Cézanne's *L'Estaque* visually level with the picture plane despite contrary invitations to the eye to see volume and mass in its rocks and trees. Running across the bottom of the picture, and probably representing the ground just forward from Cézanne's position, is a visual barrier; it acts oddly, blunting the composition's V-shape yet conspiring with it to cancel any hints of recessive space.

The least highly colored of Cézanne's paintings of L'Estaque, this picture is also the most compressed and densely structured. Lionello Venturi characterized it as possessed of "more force and less abandon" than the others. Several commentators have speculated that the structural power of this version represented a kind of "otherness" that led Cézanne's good friend, the great Impressionist painter Claude Monet, to choose this picture for his personal collection from among the many available. However that may have been, the painting's rigorous architecture is formed from and complemented by the anima-

tion and sensual appeal of Cézanne's short parallel brushstrokes. Particularly enticing is the small tree just under the dominant pine that seems to celebrate the summer afternoon in a lively jig. One of Cézanne's earliest and most profound admirers was the poet Rainer Maria Rilke, who described one of the L'Estaque paintings as "a landscape of airy blue, blue sea, red roofs, talking to each other in Green and very moved in this internal conversation, and full of understanding among one another." It might as well have been this one.

The Bather (c. 1885) Despite a monumental presence, this awkward, compellingly disturbing figure hardly represents the heroic male of Western tradition. He descends from the central figure of an engaging, rather improbable painting of ten years earlier (fig. 2), in which four bathers in a sunny, open landscape are at pains to display themselves in Academy poses. Even closer to the 1885 bather is a photograph of an anonymous studio model in an almost identical position (fig. 3). Discovered in the early 1950s pasted to the back of a Cézanne drawing, it was shortly thereafter published by Alfred H. Barr, Jr., The Museum of Modern Art's founding director. He made the photograph public, he said, "not as a curiosity or historical document but because it reveals Cézanne's greatness as few of the numerous photographs of his landscape motifs can. . . . This slightly ridiculous image of a naked young man with a mustache Cézanne transforms into one of his most monumental paintings

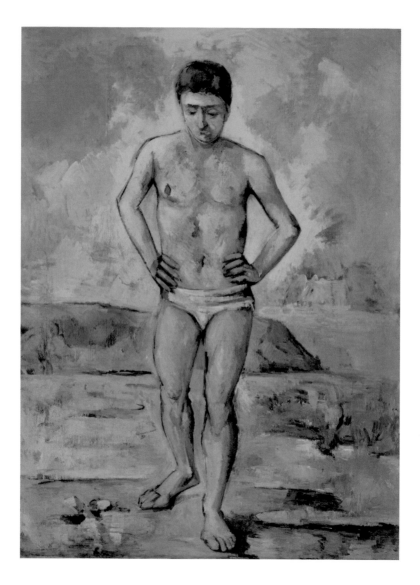

The Bather c. 1885
Oil on canvas, 50 x 38 $^1/_8$" (127 x 96.8 cm)
The Museum of Modern Art, New York.
Lillie P. Bliss Collection, 1934

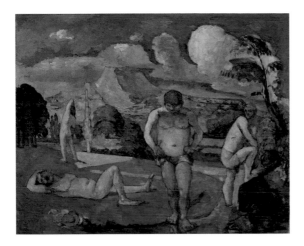

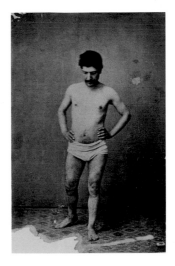

2 *Bathers at Rest* 1876–77
Oil on canvas, 32 ¹/₂ x 40" (82.6 x 101.6 cm)
The Barnes Foundation, Merion,
Pennsylvania

3 Unknown photographer
Standing model c. 1860–80
Department of Painting and Sculpture
Collection Files, The Museum of Modern Art,
New York. Gift of Curt Valentin

of the single figure. Cézanne generalizes somewhat, suppressing the idiosyncrasies of the model but without idealizing. Indeed the original humility of the individual is curiously preserved yet modified by Cézanne's intuitive sense of human dignity."

No doubt Barr was right in attributing the kind of modifications made to the photograph to the artist's sensitivity to his subject, yet the sensation aroused in him while turning the "ridiculous image" into a painting may have shifted from empathy to a feeling even closer to self-identification. To a varying extent, all of Cézanne's paintings of male bathers are autobiographical, reflective of cherished memories of his youth when he, Émile Zola, and another companion hiked and swam in the countryside around Aix. Indeed, *The Bather*'s enigmatic presence, its air of intense isolation—also inherent in related pictures of a single male bather with outstretched arms (fig. 4, for example)—must in some measure derive from the adult Cézanne's longing for bygone times. Theodore Reff's characterization of the figure with outstretched arms as "a projection of Cézanne himself, an image of his own solitary condition" applies equally to *The Bather*. Insightfully interpreting the latter, Meyer Schapiro described it as "the drama of the self, the antagonism of the passions and the contemplative mind, of activity and the isolated passive self."

Evoking oppositions fundamental to the existential dilemmas of humankind, the picture presents the eye with a surface of disjointed harmonies. Figure, water, land, rocks, and sky are painted in discontinuous patterns of flat, vigorously hatched brushstrokes whose colors promiscuously migrate. The delicious pink/peach of the man's flesh repeats in the beach, the blue

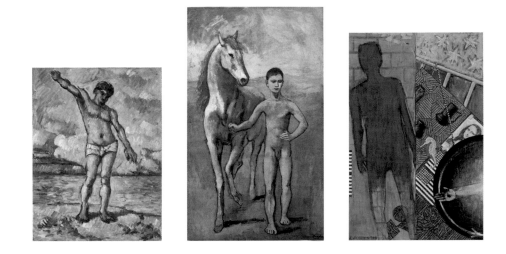

that shadows his torso and legs is borrowed from the sky, while seemingly haphazard slashes of emerald green and cobalt blue enliven the whole. Steadfast against the multiplication of lateral expanses advanced by the horizontal bands of water, beach, rocks, and sky, the vertical, even heroic, figure of the bather dominates the environment in which he participates.

The Bather has had an uncommon importance to la famille Cézanne, the innumerable artists who have been inspired by his work. Two of the many are Pablo Picasso and Jasper Johns. The painting's sense of inwardness and sheer plastic intensity are unequivocally echoed in Picasso's Boy Leading a Horse (fig. 5), completed in the year of Cézanne's death, and, decades later, they reverberate in Johns's shadow self-portraits in his Seasons series (fig. 6, for example). For a painter of yet another generation, Elizabeth Murray, The Bather was "such a beautiful evocation of a solitary figure, [and it] has always meant a great deal to me."

15

4 Bather with Outstretched Arms c. 1883
Oil on canvas, 13 x 9 ⁷/₁₆" (33 x 24 cm)
Collection Jasper Johns

5 Pablo Picasso (Spanish, 1881–1973)
Boy Leading a Horse 1905–06
Oil on canvas, 7' 2 ⁷/₈" x 51 ⁵/₈"
(220.6 x 131.2 cm)
The Museum of Modern Art, New York.
The William S. Paley Collection, 1964

6 Jasper Johns (American, born 1930)
Summer 1985
Encaustic on canvas, 6' 3" x 50"
(190.5 x 127 cm)
The Museum of Modern Art, New York. Gift
of Philip Johnson Art, 1998. © 2011 Jasper
Johns/Licensed by VAGA, New York, N.Y.

Boy in a Red Vest (1888–90)

This painting is one of four showing the same handsome, long-haired adolescent in varying poses. Unusually for Cézanne, who most often pressed family members and friends into sitting for him, the subject was a professional model. With *The Bather* of around 1885 (see p. 12), Cézanne had used his formidable skills to turn a photograph of a weary-looking studio model into a picture of enormous psychological impact; here, he matched the youthful vitality of his sitter with a correspondingly vigorous display of pictorial dynamics. Balanced by the two large triangles of the boy's body and the drapery that profiles him, the painting's surface repeats their forms in satellite shapes scattered across its expanse. In diagonal opposition and almost hard-edged geometry, the pastel-like area at the lower left and the bisected one at the upper right wedge the subject within the picture's shallow space. Vital to the structure of the boy's body are a series of smaller interlocking triangles—in the purple/blue shirt above the trousers, in the side of the red vest appearing at the back of his left arm, and in the adjacent shading of the shirt. Emerging from beneath the arm, the front of the red vest doubles the triangle in a diamond-shaped fold that reverberates in the tie's staccato patterning. Just above, a series of short, parallel brushstrokes in pink, green, and a touch of red form a small pliant triangle indicating a shadowed neck and strong jawline. Below, more juxtaposed brushstrokes in green, blue, violet, and red invest the "white" shirtsleeves with a volumetric presence so palpable the eye not only sees but synesthetically feels their bulk. Generated by tiny areas of unpainted canvas scattered over its surface, a lively sense of glancing light animates the picture.

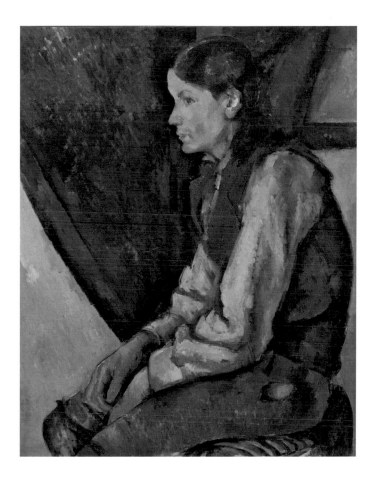

Boy in a Red Vest 1888–90
Oil on canvas, 32 x 25 ⁵/₈" (81.2 x 65 cm)
The Museum of Modern Art, New York.
Fractional gift of Mr. and Mrs. David
Rockefeller, 1955

Virtuoso as the painting may be, it is by no means a show-off. Rather, it records reality as Cézanne saw it. What he called his *motif* was, he said, his changing sensations as he strove to paint what he saw. While the exuberant execution of *Boy in a Red Vest* celebrates the strength of a youth on the edge of manhood, its sensitive depiction of the model's features catches a wary alertness, a kind of "now what?" expression not uncommon in the teenage male. Although the boy's gangly arms and disproportionately large hands served Cézanne's composition well, his treatment of them betrays an empathic sympathy for the anxious experiences of late adolescence.

The first owner of this picture was Cézanne's admirer and good friend, the great Impressionist painter Claude Monet. One privileged visitor to Giverny recalled Monet saying to him, "If you are fond of paintings, you must see the ones in my bedroom. You should also take a look at the room next to it because you'll find my best picture there." Accepting the artist's invitation, his guest recalled entering the bedroom where, to the left of the fireplace, his "eye was caught, first of all, by Cézanne's famous *Château Noir* [p. 39] . . . on the other side hung a *Vue de l'Estaque* [p. 9] and below it a *Baigneurs*. . . . I went into the adjoining room and found only one picture there, and that unframed: Cézanne's *Boy in a Red Vest*. I stood looking at it for a long time. All at once I was aware . . . that Monet had also come in, and after a long silence I heard the painter say in his deep, beautiful voice: 'Yes, Cézanne is the greatest of us all.'"

Still Life with Apples (1895–98)

In 1895, at age fifty-six, Cézanne had his first solo exhibition. Held at Ambroise Vollard's newly opened gallery in Paris, it excited the deep admiration of fellow artists such as Pierre-Auguste Renoir, Camille Pissarro, Edgar Degas, and Claude Monet and wide, if mixed, reaction in the press. The reviewer for *La Revue blanche*, Thadée Natanson, championed Cézanne, who, he wrote, "assumes in the French school the position of the new master of the still life." Implicit in those words was the judgment that Cézanne had become the equal of the revered Jean-Baptiste-Siméon Chardin. Much as that eighteenth-century painter—who chose to paint simple, domestic objects (see fig. 7) rather than the more elegant trappings of the aristocracy—might have seen a picture such as *Still Life with Apples* as an updated counterpart of his own art, he would have been baffled by Cézanne's unconventional modeling and his disrespect for one-point perspective.

Although Cézanne was a passionate observer of the art of the past, his lifelong struggle to render—as opposed to translate—the experience of seeing into painting left him no option but to abandon traditional practice. Nor could he accept Impressionism's concentration on the purely optical—excluding, so to say, the *I* from the eye. Apparently casual, the distribution of apples, lemons, and green plums across the surface of *Still Life with Apples* was, in fact, based on a studio model Cézanne had carefully arranged. Unlike the human figure or landscape, still life was the only motif that allowed the artist to prefigure his composition. Here, he used that freedom to set up analogies of color and shape that, imaged on the canvas, form a field alive

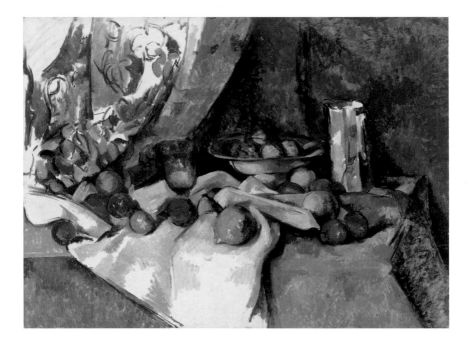

Still Life with Apples 1895–98
Oil on canvas, 27 x 36 $^1/_2$" (68.6 x 92.7 cm)
The Museum of Modern Art, New York.
Lillie P. Bliss Collection, 1934

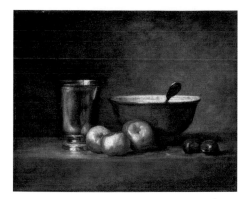

with reverberating visual rhymes. Modulated (Cézanne's preferred verb) in glowing color, the various pieces of fruit seem to be possessed of an inner density that may provide an anchoring force against the table's pronounced forward tilt. At lower left, the juncture of the beige cloth at table edge barely counters the downward list visible in the white cloth and continuing through the blue one, at right. This partially frontal, partially aerial perspective replicates how a moving observer's view changes from instant to instant and goes further to implicate the instability of ourselves and all we see. Minus some metaphysical baggage, the example of Cézanne's skewed translations of traditional perspective was crucial to Georges Braque and Pablo Picasso in their joint invention of Cubism in the years immediately following the 1906 death of the old man Picasso called "the father of us all." Despite his legendary despair over his failure to achieve his goals, Cézanne had some notion of his significance. He called himself *un jalon* (a surveyor's stake): "I point the way, the others will come after."

In its own time and later, *Still Life with Apples* and other

7 Jean-Baptiste-Siméon Chardin
(French, 1699–1779)
The Silver Goblet c. 1760
Oil on canvas, 13 x 16 ¹/₄" (33 x 41 cm)
Musée du Louvre, Paris

Cézanne paintings occasioned criticism on the grounds that they are unfinished. Presently, a general understanding holds these paintings to be fully resolved, the unpainted areas reflecting the artist's estimation that they were essential to the expressive power of a given picture. Pissarro seems to have thought them particularly potent. Writing to his son about the 1895 Vollard exhibition, he praised "Cézanne's exquisite things, still lifes of irreproachable perfection, others, *much worked on* and yet unfinished, of even greater beauty." Late in the twentieth century, David Sylvester saw Cézanne's *non finito* as a "metaphor for becoming," an interpretation not so far from Natanson's 1895 vision of it as "a mysterious summons from the future."

Émile Bernard (French, 1868–1941)
Cézanne Painting in His Studio 1905
Black-and-white photograph, 4 $^7/_8$ x 2 $^{15}/_{16}$"
(12.4 x 7.5 cm)
Musée d'Orsay, Paris

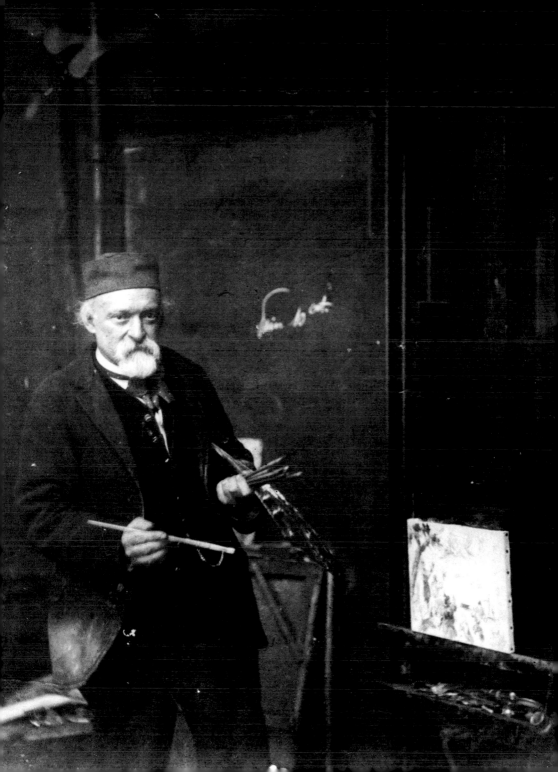

Foliage (1895)

Surprising the eye the way an unintended glimpse of foliage radiant with dappled sunlight might, this watercolor is the sparkling equivalent of its subject. Its ability to astonish as nature astonishes owes, of course, to Cézanne's particular artfulness. Without contour lines or any concessions to linear perspective, the image is formed through "the contrast and connection of colors," the method Cézanne held to be "the secret of drawing and modeling." That "secret," as examined in a present-day laboratory by paper conservator Faith Zieske, was analyzed as follows: "Cézanne's watercolor technique allowed the images to unfold through a subtle interplay of overlapping strokes of thin washes of color. . . . Rarely were the pigments mixed on the palette before application; instead, superimposed patches of translucent color create additional tints. This layering technique required restraint and practiced precision, as it did not allow for scraping out or erasing mistakes. Long drying times were necessary between overlapping strokes, for if the underlying colors were still moist, they would merge and run together." Thus the prismatic sparkle of *Foliage*'s blue, yellow, red, green, and violet strokes is not what it seems—not the index of immediate, improvisational response, but of elation tempered by patience.

Meticulously crafted, this small watercolor preserves the intensity of Cézanne's amazement before nature's wonders, his joy in the fugitive moment. Placeless, anonymous, close to abstract, *Foliage* is its own pictorial world, its white sheet the colorless light of a summer day. It fits poet Rainer Maria Rilke's description of another Cézanne watercolor as "wonderfully arranged and with a security of touch: as if mirroring melody."

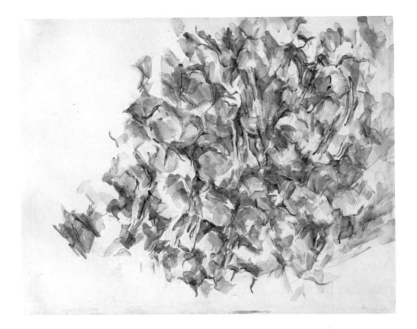

Foliage 1895
Watercolor and pencil on paper,
17 ⁵/₈ x 22 ³/₈" (44.8 x 56.8 cm)
The Museum of Modern Art, New York.
Lillie P. Bliss Collection, 1934

Pines and Rocks (Fontainebleau?) (c. 1897)

Whether Cézanne set up his easel to begin this picture in Fontainebleau forest or, as some propose, in the countryside around his native Aix, the completed painting embodies the artist's will "to introduce into our light vibrations, represented by the reds and yellows, a sufficient amount of blueness to give the feel of air." Animated by flecks of the warm primaries, white, and tiny areas of bare canvas, the cool-but-bright blue sky of *Pines and Rocks (Fontainebleau?)* vibrates between the coppery-red trees to such synesthetic effect that the circulation of air is almost palpably evoked. Adding to the overall sense of light-generated airiness is a canny way with the application of paint. In the vertical bands at left and right, pigment fades to a thin, vaporous layer, while below, the shadows cast by the trees in violet, other mixtures of the primaries, and bright green are more substantial.

The painting's emphasis on evanescent, glancing light tends to recall Impressionism, but its composition is meticulously structured. As Cézanne famously claimed, he wanted to "redo Poussin after nature"—to achieve the timelessness implicit in the seventeenth-century master's idyllic landscapes (such as fig. 8) while preserving the living sensations aroused in him by whatever corner of God's kingdom he chose to paint. Thus, to approximate the nearness of the sensual, material world around him, he had to abandon, among many other traditions of Old Master painting, the perspectival conventions that had guided Poussin.

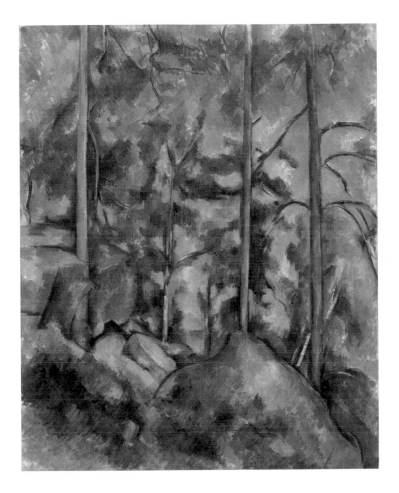

Pines and Rocks (Fontainebleau?) c. 1897
Oil on canvas, 32 x 25 ³/₈" (81.3 x 65.4 cm)
The Museum of Modern Art, New York.
Lillie P. Bliss Collection, 1934

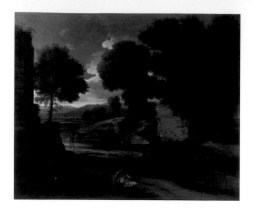

Accordingly, the painting all but banishes indications of deep space. Exactly at lower center a very small upside-down pyramid, pale blue at the bottom then merging to pink and a deeper blue, is wedged between the edge of the largest rock and a hillock's curve. If the resultant tiny lateral stretch hardly persuades as a glimpse of some distant shore, it is phenomenally effective when it is understood, however subliminally, as the apex of the vast inverted triangle of the sky. Upended, the convergent orthogonals of classical perspective push the expanse of sky toward rather than away from the observer's eye. Within the shallow space thus established, the three largest pines structure the composition vertically and, echoed in two small trees at lower center, insinuate possibilities of recessive space.

In Cézanne's art, trees are seldom without character, and the three tall sentinels of *Pines and Rocks* are no exception. The slender, nervelike branches of the two on the right repeat the contours of the rocks from which they seem to emerge, while the one to the left appears engaged in an affectionate game with the gentle boulder in front of it. The foliage of the trees seems independent of them. Dark and concentrated around the left

8 Nicolas Poussin (French, 1594–1665)
Landscape with Travellers Resting c. 1638–39
Oil on canvas, 24 $^{13}/_{16}$ x 30 $^{5}/_{8}$"
(63 x 77.8 cm)
The National Gallery, London

tree, its mass is represented by an abstract shape that appears to be dispersing and fragmenting as it moves "east" across the canvas. While ingeniously evoking the soft rustle of wind in the trees, the migrating leaves also imply a world in which nothing is ever quite stable. Reflecting on Cézanne's landscapes, D. H. Lawrence wrote, "We are fascinated by the mysterious *shiftiness* of the scene . . . it shifts about as we watch it. And we realize with a sort of transport, how intuitively *true* this is of landscape. It is *not* still. It has its own weird anima. . . . This is a quality that Cézanne got marvellously."

Turning Road at Montgeroult (1898)

In 1898 Cézanne summered in Montgeroult, a village northeast of Paris, not far from Pontoise, where he had once painted in close companionship with Camille Pissarro. This painting is one of the last landscapes the artist made in the Île-de-France region before retreating to his native Aix, where he spent his last years in almost hermitlike isolation. Heavily damaged in World War II, the site of *Turning Road at Montgeroult* is no longer recognizable, but a photograph taken in the mid-1930s (fig. 9) shows that Cézanne followed the local topography with some fidelity. Meyer Schapiro wrote that such a scene "was fascinating to the artist as a problem of arrangement—how to extract an order from the maze of bulky forms. It is one aspect of the proto-Cubist in Cézanne."

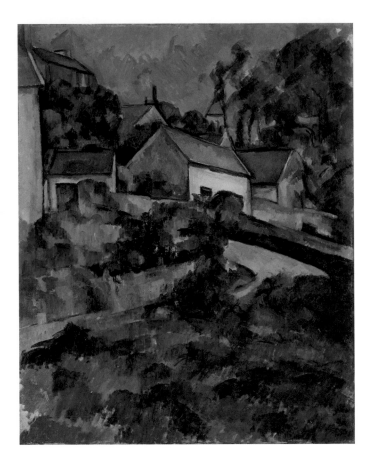

Turning Road at Montgeroult 1898
Oil on canvas, 32 x 25 ⁷/₈" (81.3 x 65.7 cm)
The Museum of Modern Art, New York.
Mrs. John Hay Whitney Bequest, 1998

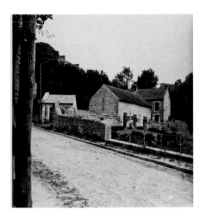

Definitively ordered, the picture negotiates a union between starkly geometric structure and amorphous, organic mass. Only a little bit less than half of the canvas is covered by abstract, thinly brushed foliage in cool greens, blues, and browns in pulsing, forward movement. Just shy of center, the glowing yellow road, in concert with the dark thrust of the adjacent wall, simultaneously cuts off the vegetal advance and carries it into the zone of houses above. Insinuating itself in dark-green clumps beside and between the houses and finally, massively, into the sky above, the foliage unites the composition while organically locking together the assorted rectangles, parallelograms, and triangles of the hodgepodge cottage walls. In glowing, sunlit contrast to the jumble of vegetation surrounding them, the more thickly painted planes of the houses take part in the upward compositional thrust established by the rhythmic, constructive brushstrokes of the greenery crowding the bottom of the painting.

31

9 Motif for *Turning Road at Montgeroult*, c. 1933–35. Photograph by John Rewald. John Rewald Archive, Department of Image Collections, National Gallery of Art Library, Washington, D.C.

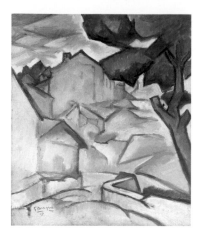

Where Schapiro saw the pictorial ordering of works such as *Turning Road at Montgeroult* as a challenge to the proto-Cubist in Cézanne, a later art historian, William Rubin, considered it from a more precise angle. Arguing that Georges Braque had an early edge on Pablo Picasso in their joint "pioneering" of Cubism, Rubin held that Braque's 1907 *Landscape with Houses* (fig. 10) "may be considered a proto-Cubist paraphrase of such pictures as the *Montgeroult*."

10 Georges Braque (French, 1882–1963)
Landscape with Houses October–
November 1907
Oil on canvas, 21 $^1/_4$ x 18 $^1/_8$" (54 x 46 cm)
Private collection

Still Life with Ginger Jar, Sugar Bowl, and Oranges

(1902–06) In this densely worked painting, oranges, crockery, and tablecloth are all keyed to a compositional system not just sketched out, but put in place in advance of its execution. For Cézanne, whose rigor in the ordering of his landscapes often obliged him to gain some knowledge of a formation's geological structure before committing it to canvas, the compositional control afforded by still life was especially attractive and may account for its high-percentage appearance in his oeuvre. Here, he elected to set up the things he would paint in a tighter, more centralized group than was often the case.

Cézanne greatly admired Gustave Courbet, and following the realist principles of the older artist (see fig. 11) he chose to paint common household objects without allusions to luxury or high culture. Some of these, appearing over and over again in his paintings, seem to have inspired the artist with an affection that comes with familiarity and long usage. One of the most ubiquitous is the beautifully rendered blue/white ginger jar at right center in this painting. Its appearance in an earlier still life (fig. 12) was remarked by the poet Rainer Maria Rilke, who described it as "an exquisite, large, gray-glazed ginger jar, whose right and left sides don't align." The apparent chromatic inconsistency of the ginger jar in the two canvases largely reflects Cézanne's perception of it under variant conditions, while the differences in the sugar bowl are compositional.

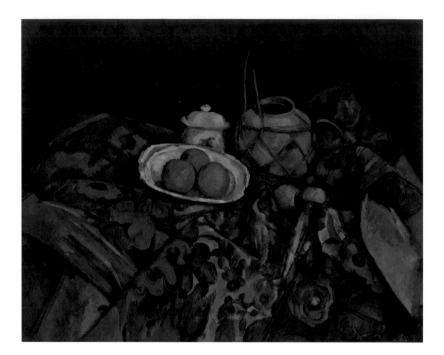

Still Life with Ginger Jar, Sugar Bowl, and
Oranges 1902–06
Oil on canvas, 23 $^7/_8$ x 28 $^7/_8$" (60.6 x 73.3 cm)
The Museum of Modern Art, New York.
Lillie P. Bliss Collection, 1934

Rilke's observation that in the 1893–94 canvas the sides of the ginger jar are not aligned may also be made of the later work. Indeed, there is very little in The Museum of Modern Art's painting that is not slightly skewed. As in natural vision (as opposed to artistic convention), the plate, sugar bowl, ginger jar, and oranges are without contour lines—illusions of depth and volume result from the nuanced gradations of color that constitute their forms. With the exception of the two oranges hiding within extravagant folds of cloth at right, the objects on the unseen tabletop are possessed of a stability that seems to defy gravity. The cloth that looks like it might be supporting them was another of Cézanne's favorite props, both in still lifes and in figure paintings (see fig. 13). As was sometimes his prac-

35

11 Gustave Courbet (French, 1819–1877)
Still Life with Apples and a Pomegranate
1871–72
Oil on canvas, 17 1/2 x 24" (44.5 x 61 cm)
The National Gallery, London

12 *Still Life with Apples* 1893–94
Oil on canvas, 25 3/4 x 32 1/16"
(65.5 cm x 81.5 cm)
Private collection

tice, he may have built up its massive folds with wedges or other devices in order to create a tabletop landscape that mimics geological structure. The result he most often sought was a triangular mass referring without disguise to the shape of his beloved Mont Sainte-Victoire. Here, the allusion to the mountain is less obvious but is nevertheless present in three cloth pyramids, one at the bottom and two flanking the centrally positioned ginger jar, sugar bowl, and plate with oranges.

The role Cézanne accorded decorative fabric in compositions such as this was a device Henri Matisse would prominently pick up around 1910 (fig. 14). As for the ginger jar, its shape is recognizable in the work of several members of the new century's avant-garde. Especially notable is its appearance in Piet Mondrian's *Still Life with Gingerpot II* (fig. 15) of 1912.

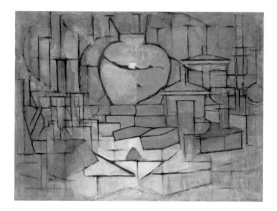

13 *Young Italian Woman at a Table*
c. 1895–1900
Oil on canvas, 36 1/8 x 28 7/8" (91.8 x 73.3 cm)
The J. Paul Getty Museum, Los Angeles

14 Henri Matisse (French, 1869–1954)
Still Life with Blue Tablecloth 1909
Oil on canvas, 34 13/16 x 45 11/16" (88.5 x 116 cm)
State Hermitage Museum, St. Petersburg

15 Piet Mondrian (Dutch, 1872–1944)
Still Life with Gingerpot II 1912
Oil on canvas, 36 1/2 x 47 1/4" (91.5 x 120 cm)
Solomon R. Guggenheim Museum,
New York, on permanent loan from the
Gemeentemuseum de Haag, Netherlands.
© 2011 Mondrian/Holtzman Trust
c/o HCR International, Virginia

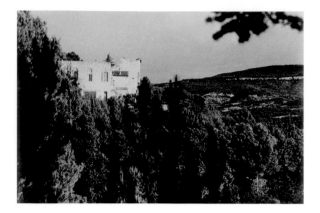

Château Noir (1903–04) Inarguably,

the "château" of this painting's title is neither black nor in any traditional sense a château. Dating from the mid-nineteenth century, the building was scarcely antique, yet its strange appearance had already inspired many local legends by the early 1900s, when Cézanne made this painting and four similar versions. The structure's designation as black may have owed to the reputation of its first owner, alleged to have been an alchemist in league with the devil—hence its alternate name, Château du Diable. Secluded on a steep bluff amid dense pinewoods, the house, with its Gothic architecture and unfinished orangerie, had the look of an abandoned ruin, remote and impossible to reach (fig. 16).

For all its faraway allure, Château Noir was, in fact, a carriage ride away from Aix, where Cézanne lived from 1899 until his death in 1906. Situated in an area replete with motifs dear to him and itself offering a splendid view of Mont Sainte-Victoire

38

16 Château Noir, Aix-en-Provence, c. 1935.
Photograph by John Rewald. John Rewald
Archive, Department of Image Collections,
National Gallery of Art Library, Washington,
D.C.

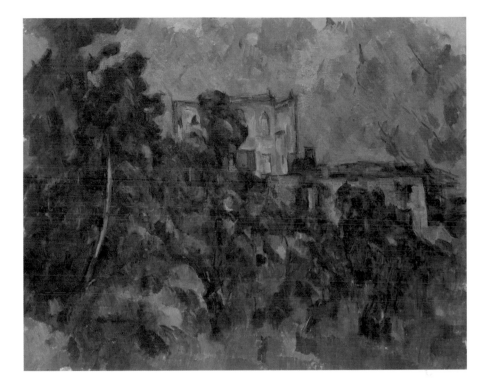

Château Noir 1903–04
Oil on canvas, 29 x 36 3/4" (73.6 x 93.2 cm)
The Museum of Modern Art, New York.
Gift of Mrs. David M. Levy, 1957

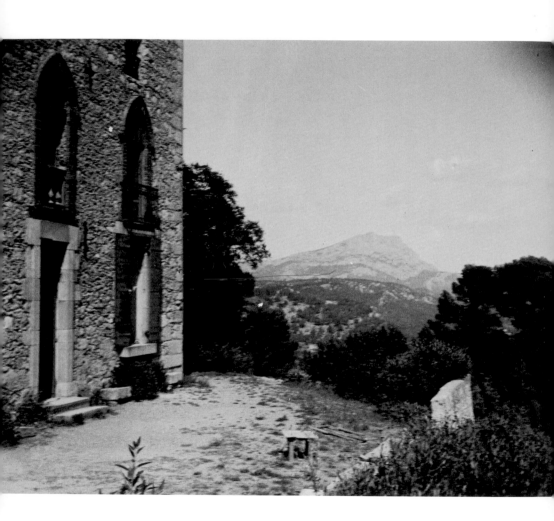

40

17 Mont Sainte-Victoire seen from
the terrace of Château Noir, c. 1950.
Photograph by John Rewald. John Rewald
Archive, Department of Image Collections,
National Gallery of Art Library, Washington,
D.C.

(fig. 17), it so appealed to Cézanne that he tried to buy it in 1899. Although his offer was rebuffed, he was able to rent a small room in which to store his paraphernalia and permitted to work outside the building wherever he wished. Painting this version of the château, Cézanne seems to have situated himself somewhere opposite it, at a height sufficient to show its facade and terrace head-on against the rising mass of treetops. Although trees make up more than half of the diagonally divided composition, their weight is alleviated by seemingly random flashes of yellow greens and pale blues flickering among the darker greens and browns of their abstractly rendered foliage and definitively countered, if not canceled, by the glowing yellow/orange of the house's walls, made even more vibrant by the Indian red of its central door. The variegated blues of the sky above halo the château's outlines, act chromatically as another visual foil to the luminescent house, and seem every bit as visually tactile as the foliage below or the summit of Mont Sainte-Victoire, whose mass they obscure. The short parallel brushstrokes of the previous decade are replaced here by a network of crisscrossing brushstrokes, often moving in conflicting directions across the painting's surface. It could have been this picture, which he certainly knew, that Willem de Kooning had in mind when he asserted that in a Cézanne every brushstroke has its own perspective.

More critics than not have interpreted the high drama of the Château Noir paintings of the last years of Cézanne's life as a kind of investment of self even deeper than the empathic relation to nature often evidenced in his earlier landscapes. Considering another, very similar late *Château Noir*, Joseph J.

Rishel found it charged "with a gothic emotionalism worthy of [Eugène] Delacroix." He went on to explain, "Not, of course, an incarnation of the romanticism of Delacroix . . . as much as Cézanne may be rekindling those passions from his youth." Whether or not Château Noir provoked any specific echoes of the artist's youth and its extravagant dreams, the passionate intensity of the canvases he painted of it is only equaled in the awkward, deeply felt pictures of his early years. Indeed, the Château Noir site could be deemed an appropriate, if insufficiently tenebrous, locus for the ambiguous drama of Cézanne's 1867 canvas *The Abduction*, a painting a contemporaneous critic thought could have fallen from the table of Delacroix, like "tiny balls of bread kneaded with thick fingers." Some four decades later, Cézanne's fingers were far from thick. No less a connoisseur than the great Impressionist Claude Monet prized this painting as one of the finest in his collection.

Cézanne, c. 1861.
Musée d'Orsay, Paris

Paul Cézanne

was born on February 22, 1839, in Aix-en-Provence, France. During his school years in Aix, he and Émile Zola became fast friends, one dreaming of becoming an artist, the other a writer. Cézanne's father, a prosperous banker, opposed his son's wishes, and it was not until after a failed attempt to become a lawyer and a subsequent brief stint in the family bank that he could fully devote himself to art.

In 1861, during his first extended stay in Paris, Cézanne met Camille Pissarro and soon after came to know most of the Parisian avant-garde. Beginning in 1864 he regularly submitted work to the official Salon, where it was consistently rejected, and although he never fully committed himself to Impressionism, he took part in the movement's first exhibition, in 1874, and its third, in 1877. His father's death in 1886 left Cézanne with a fortune that allowed him to work free of financial worries. In 1895 his first solo exhibition was held at the Galerie Ambroise Vollard in Paris, exciting much attention, both favorable and derisive. Four years later the artist returned full-time to his native city, where he lived in seclusion until his death in 1906. Almost immediately thereafter, his art critically influenced Henri Matisse and Fauvism and led to Georges Braque and Pablo Picasso's development of Cubism. Born in the first half of the 1800s, Cézanne is presently recognized as twentieth-century modernism's presiding genius.

Produced by
The Department of Publications,
The Museum of Modern Art, New York

This publication is made possible by
the Dale S. and Norman Mills Leff
Publication Fund.

Edited by Rebecca Roberts
Designed by Amanda Washburn
Production by Tiffany Hu

Printed and bound by Oceanic
Graphic Printing, Inc., China
Typeset in Avenir
Printed on 140 gsm Gold East Matte
Artpaper

Library of Congress Catalogue Card
Number: 2011927409
ISBN: 978-0-87070-789-6

Published by
The Museum of Modern Art
11 West 53 Street
New York, NY 10019-5497
www.moma.org

Distributed in the United States
and Canada by
D.A.P./Distributed Art Publishers, Inc.
155 Sixth Avenue, 2nd Floor
New York, NY 10013
www.artbook.com

Distributed outside the
United States and Canada by
Thames & Hudson, Ltd.
181 High Holborn
London WC1V 7QX
www.thamesandhudson.com

Printed in China

Photograph Credits